EX LIBRIS

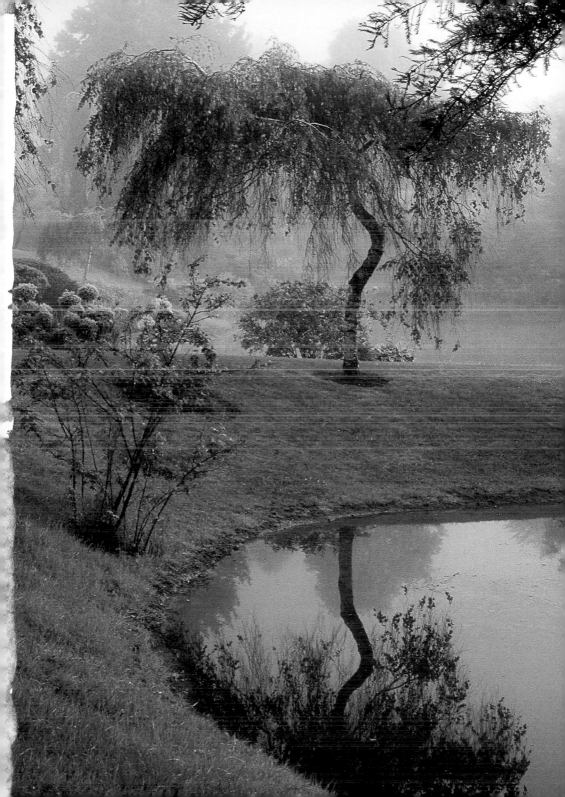

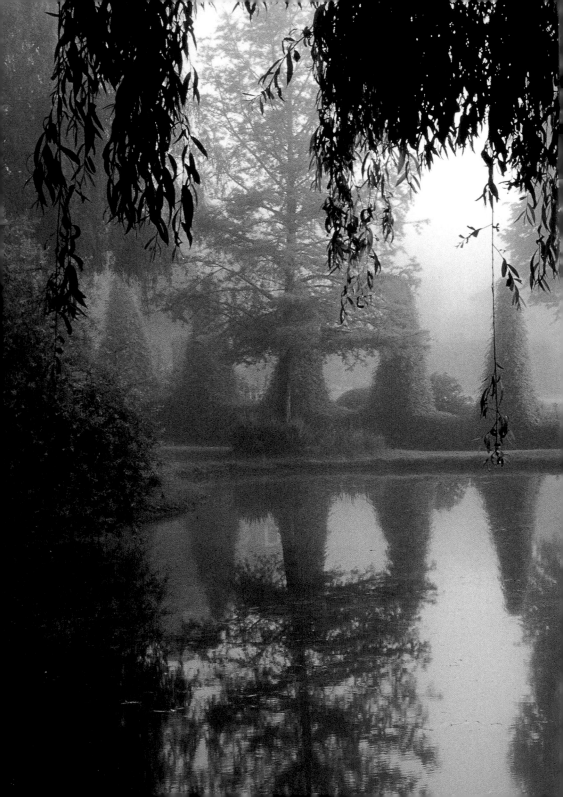

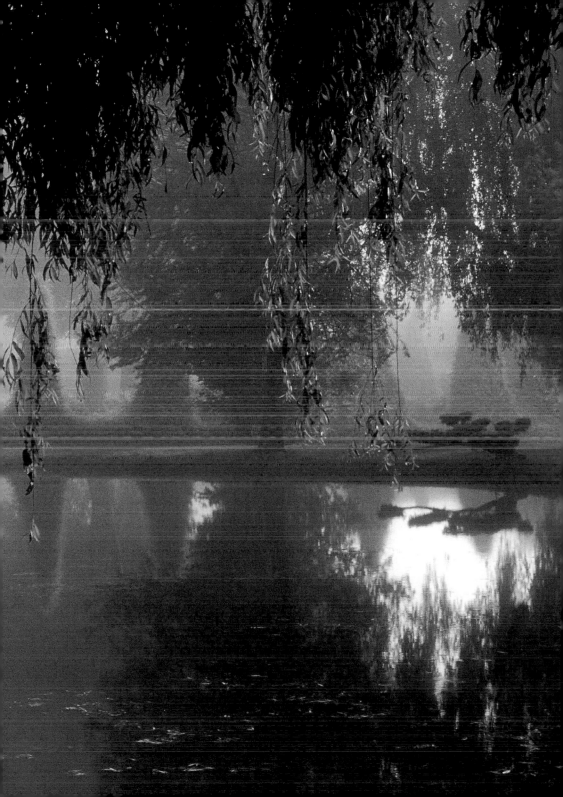

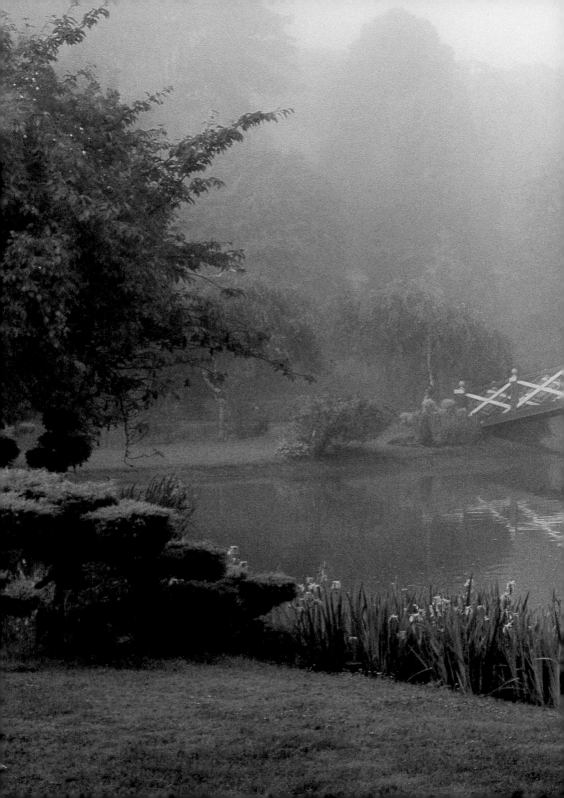

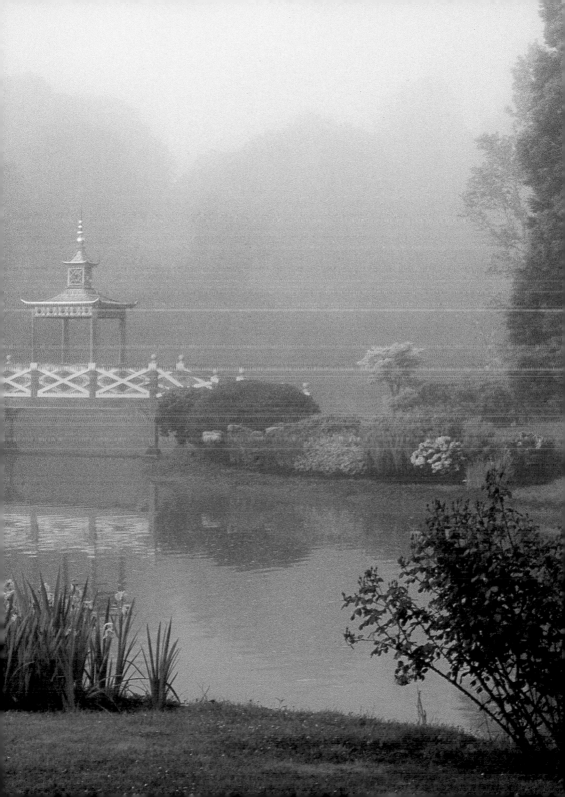

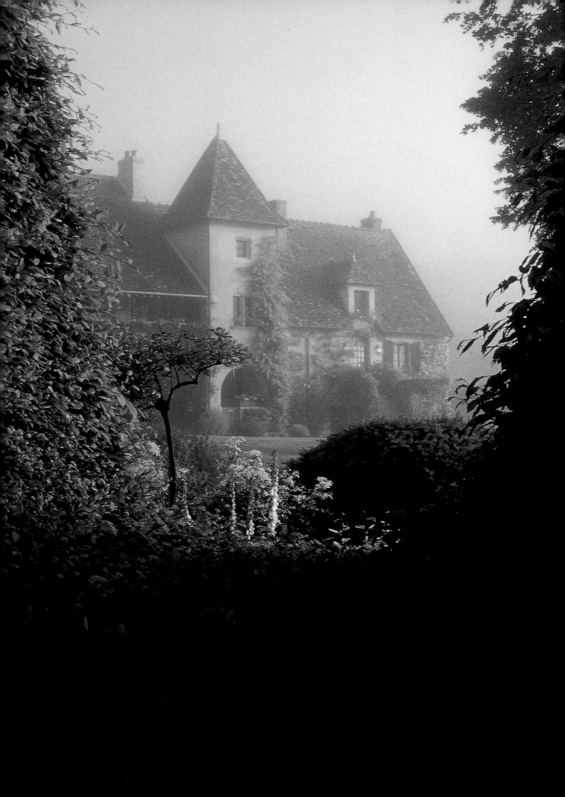

Photographs by Claire de Virieu
Text by Gilles de Brissac
and Gabrielle Van Zuylen

Apremont

A French Folly

The Vendome Press
New York

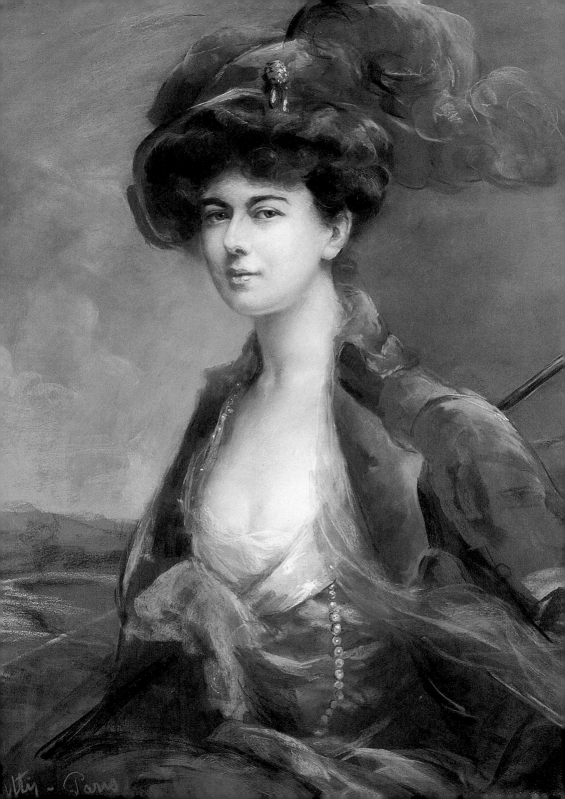

Contents

*"Les paradis perdus,
il n'y a qu'en soi-même
qu'on les retrouve."*
*"We find our lost paradise
only in ourselves."*
Marcel Proust

Antoinette de Saint-Sauveur
of Apremont

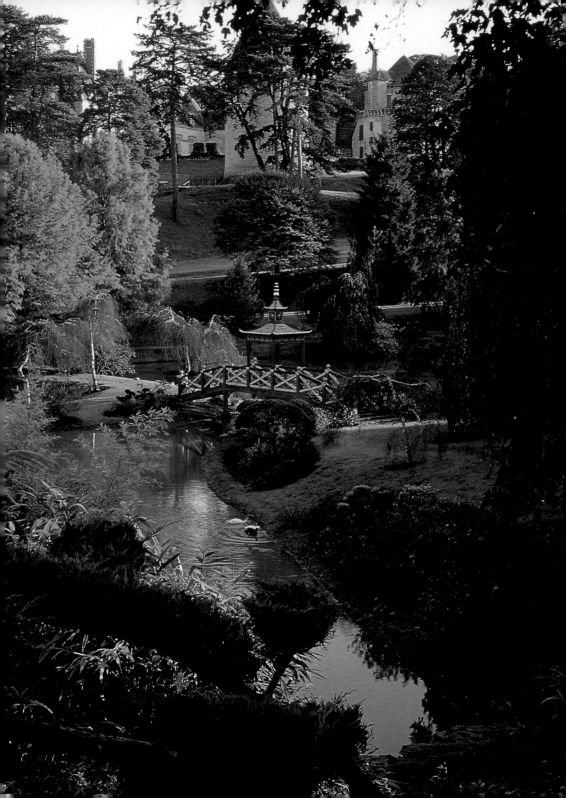

The Floral Park
of Apremont

The floral park at Apremont-sur-Allier lies in the heart of France in the region of Berry some ten miles from the city of Nevers. The site is an exceptional fairy tale of beauty and timeless serenity. On the left bank of the river a castle rises, at its feet a line of enchanting medieval houses, each with a small garden, topiary hedges, and flowering vines and creepers, follows the curve of the tree lined riverbank. Trees and green fields cover the far bank of the Allier as it makes a large loop to join the mightier Loire.

The promenade along the village street and the river's edge is slow, as one lingers over the variety and charm of each house and garden. Bewitching little gardens open onto the road, forming a bright ribbon of English-style cottage gardens in this old French setting. Large flowered clematis and heavy roses wreathe windows and doors and plants spill from window boxes, and some riverside back gardens are buttressed by

For captions of previous illustrations, see page 80. *Opposite*: The ancient fortified castle, which has not been taken by an enemy since the sixteenth century, now oversees and protects its garden kingdom.
Overleaf: The Russian-inspired belvedere, the last folly built at Apremont, overlooks the white cattle of the Charente grazing on the hillside, the village, and the broad curve of the Allier through the landscape.

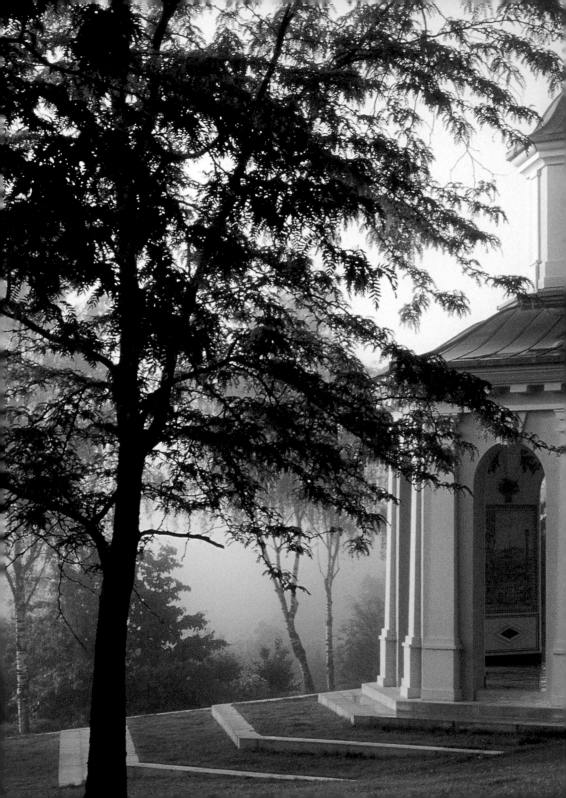

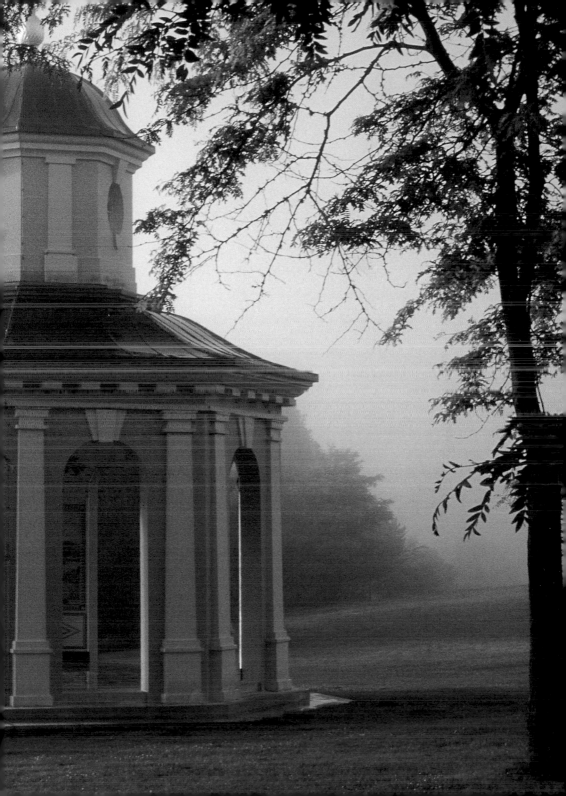

strong topiary hedges. The atmosphere is of a past world suddenly rediscovered.

The transition from the village to the floral park is smooth. The garden gates open toward what was once the village square, where, at the turn of the century, domestic animals were bought and sold under the same huge lime tree that centers the green lawn and the curve of the magical White Garden, the starting point of the itinerary through the floral park. The deep mixed border planted in tones of white, silver, gray, and green is backed by a hedge that rises into high, regularly spaced, pointed columns opening on tantalizing broken views of the castle in the distance and the nearer necklace of linked ponds and lakes, the stunning red Chinese bridge and the far Turkish pavilion at the end of the narrowing valley. The White Garden faces the back of the village and a path under a flowered pergola that meanders along the cottage gardens. The path winds toward the cascade at the top of the restored stone quarry, now a superbly planted rock garden on the side of the falling water that leads down to the walks circling the valley and lakes beneath the castle.

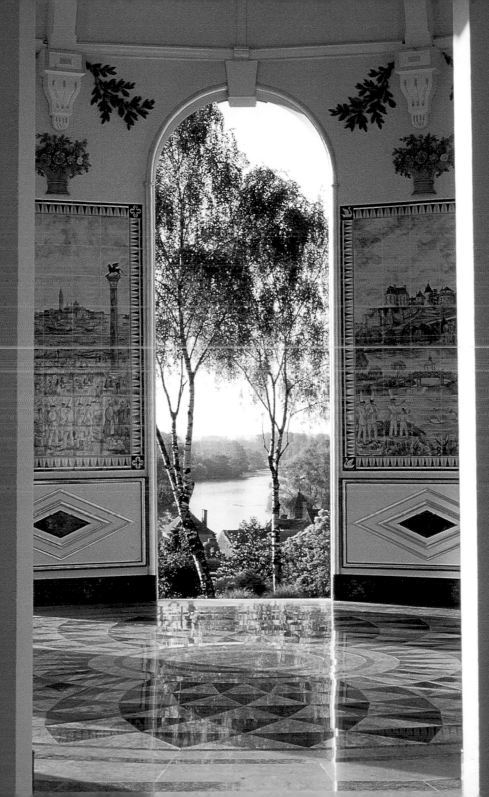

A Brief History
of Apremont
and the Creation
of the Gardens

A castle has dominated the strategic heights of the Allier River since the thirteenth century. The fortress was taken and destroyed during the fifteenth-century war between Louis XI and Charles the Bold, then was rebuilt and so strongly fortified that since the early sixteenth century it has survived all battles and sieges. As of 1772 it has been directly inherited through the female line.

Gilles de Brissac, the youngest son of the last of this line and the creator of the floral park, opened the park and village to the public in 1977, but the story of the garden stretches back to the 1894 marriage of his grandmother, Antoinette de Saint-Sauveur, to Eugène Schneider. This renowned industrialist and master of the ironworks of Creusot developed a deep passion for his wife's heritage, even reopening the stone quarry to restore the castle. In the 1930s he patiently and exactingly returned the village to its medieval beauty,

and pulled down and rebuilt houses not in the appropriate regional and period style. Each part of the property fed his interest. He laid out a huge walled kitchen garden, separated it from the castle with a wood traversed by formal walks. Now grown to full glory, this wood and the American oaks bordering the property are part of the testimony to his endless planting and planning. Madame Schneider was widowed in 1942 and returned to her family's property after the Liberation. She distributed packets of seeds to villagers and gave prizes for the prettiest gardens, decades before the continuing competitions for best floral villages of France. She also gave her beloved grandson Gilles *carte blanche*, an open checkbook, and a full charge to do what he wanted at Apremont.

Topiary hedges enliven the sober stones of Apremont.

When asked what possessed him to undertake the vast and endless task of transformation and creation at Apremont, Gilles de Brissac cites the beauty of the place and his wish to preserve and share it with others, as well as his pedagogical urge to display to his

Overleaf: Two black swans, won in a bet with a friend, recall memories of well-stocked ponds and lakes seen during Gilles de Brissac's summer vacations in England.

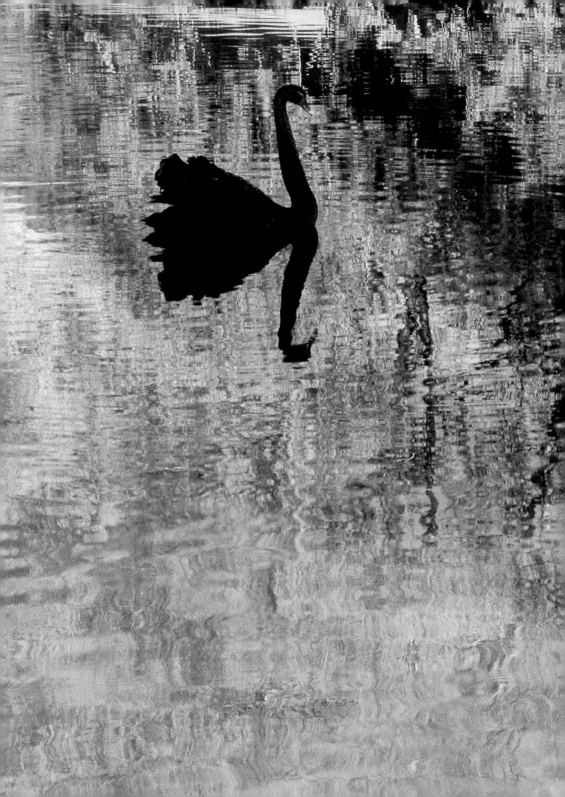

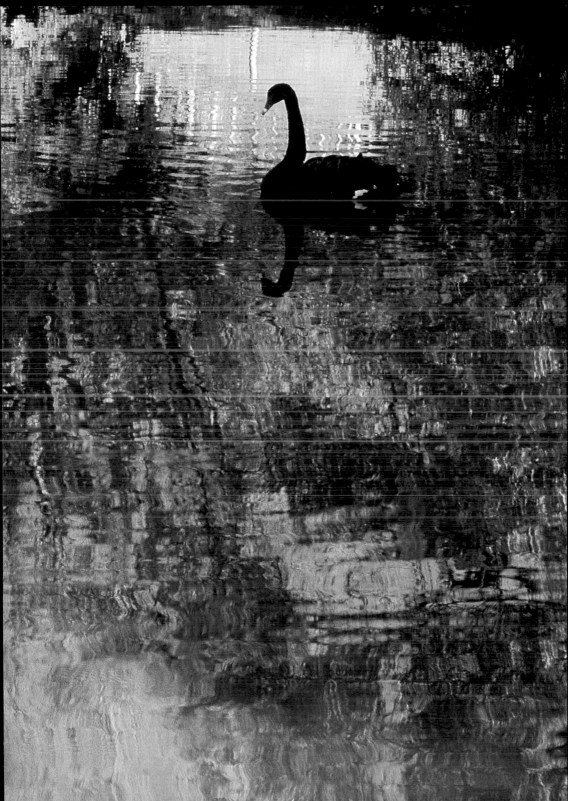

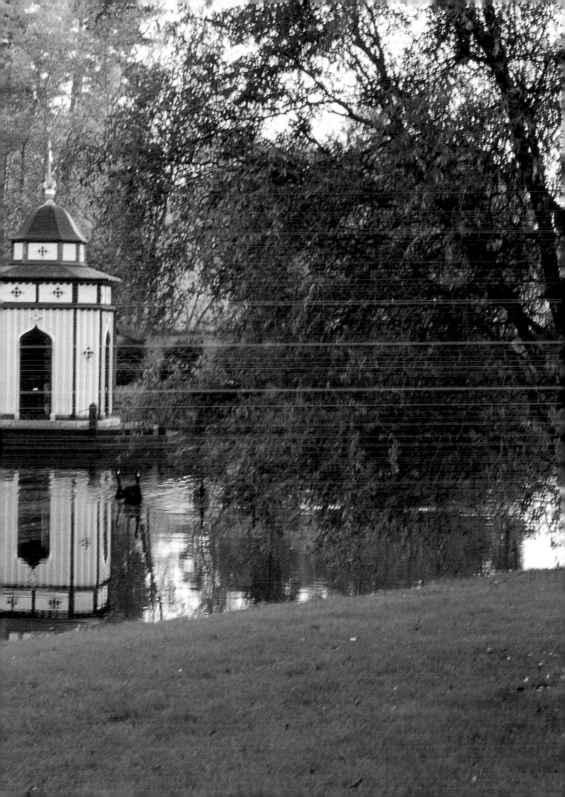

Previous pages: The Turkish pavilion, the second folly designed by Alexander Serebriakoff, seems to float at the end of the second lake. This architectural element entices the visitor to the far end of the circuit where the park blends into the borrowed landscape of adjacent meadows and fields.

Opposite: The park's real white cat poses above a trompe l'oeil white rat beneath one of Jacques Roubinet's Four Seasons paintings in the octagonal Turkish pavilion. The picture represents spring as La Bayadère.

countrymen the rich and endless variations possible in gardening. Most gardens in France at the time were rather tasteless, frozen in the nineteenth-century style of Napoleon III: public parks with floating beds and somber shrubs. After World War II few varieties of plants, shrubs, and trees were available in nurseries, garden centers did not exist, and there were few books on gardening and no general interest. Gilles de Brissac vowed that at Apremont "the French public would soon have examples other than the infernal omnipresent marriage of red salvias and yellow Marigolds and depressingly dull aligned thuyas." His deepest wish was to continue his grandparents' work here on their beloved property. "Faced with an endless gratitude for all that I know, the little I know, I wanted to express my admiration and do them homage."

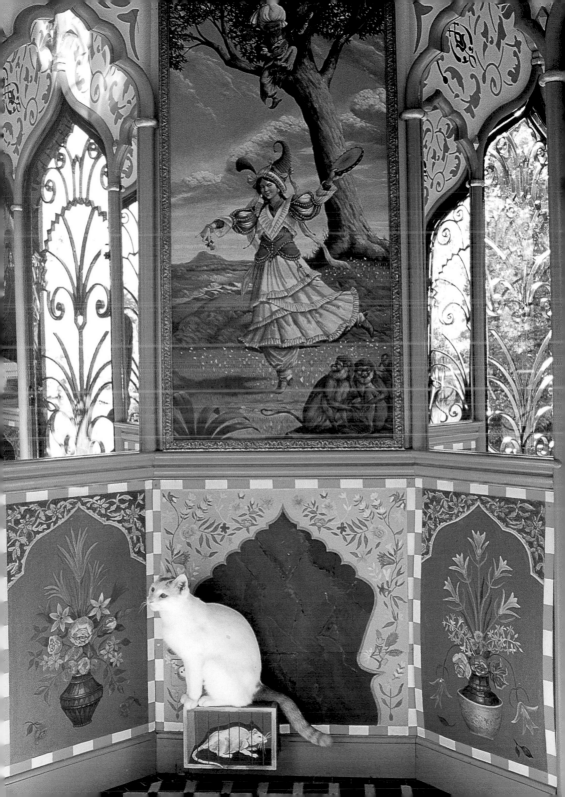

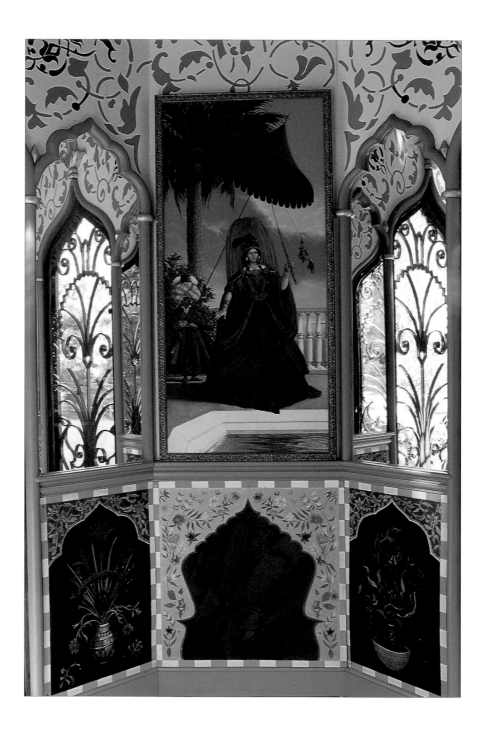

A Gardener's
Education

G illes de Brissac's early youth before the war was spent with his grandparents at La Clairière, their home outside Paris, behind high walls crowned with *Polygonum baldschuanicum* rising above heavy-scented honeysuckle. The house and garden were a haven from the terrible events of the late thirties. "I was four years old, and the evening tour of the park in the company of my grandparents was the most appreciated moment of my day." The garden of hedges, paths, and trellises was very French in design and filled with various roses with magical names and the mingled scents of June.

It is rare to be able to trace the education of a gardener, the steps and stages, the successes and failures that combine alchemically to make a great garden; Gilles de Brissac presents this opportunity. After the war he was sent to England every summer; the first year to stay with a simple middle-class family in a village near

Opposite: A Turkish sultana and her turbaned page symbolize summer. The interior of the pavilion was painted by Pierre Breger with decorations fittingly inspired by those seen in the Topkapi Palace in Istanbul.
Overleaf: Purple and the occasional golden *Iris sibirica* are but two of the many varieties of water-loving plants that soften and enhance the borders of the two lakes to make the promenade a botanical as well as visual delight.

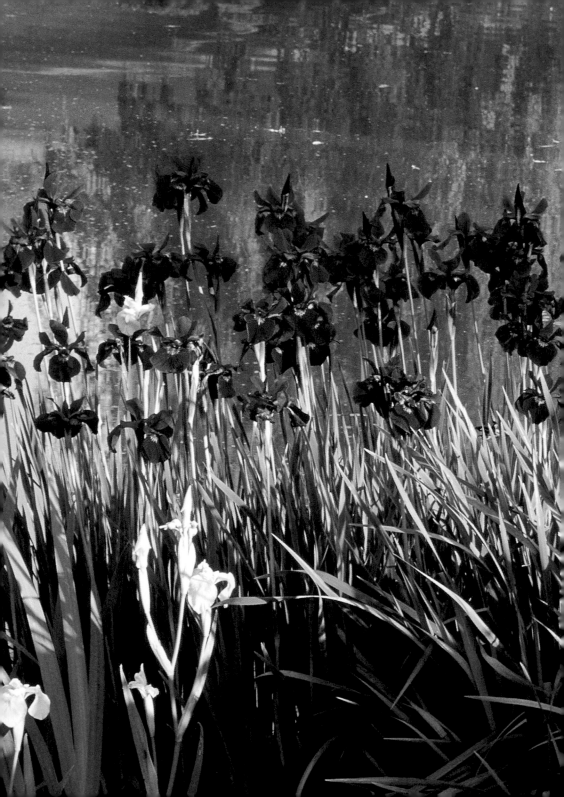

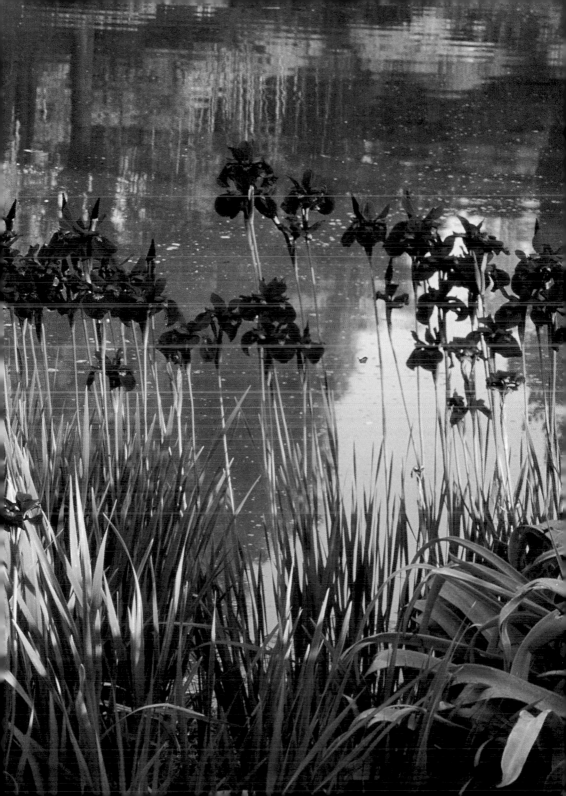

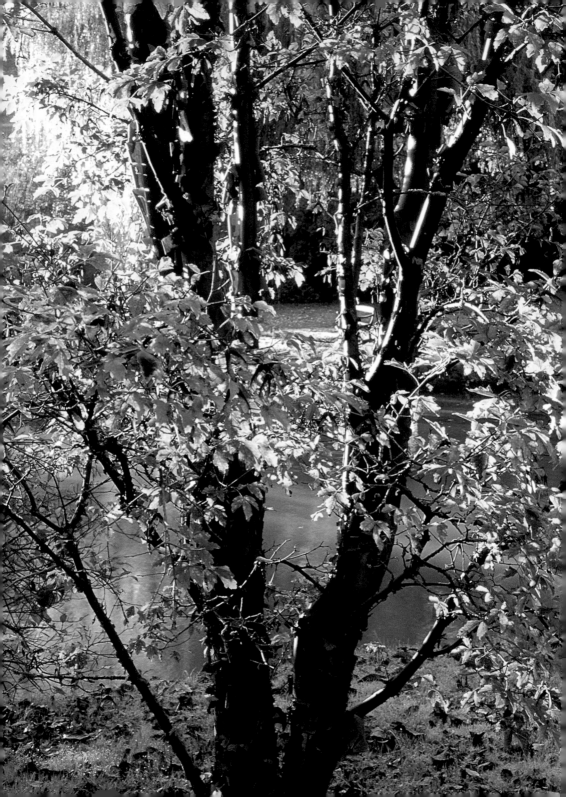

Bristol. During the day, when her husband was at work and her children at school, the wife looked after him. When she discovered his love of gardens she bought guidebooks and overcame her fear of cars to drive him slowly around the countryside to visit whatever they could find. This was his introduction to the beauty of the English landscape, cottage gardens, a more natural

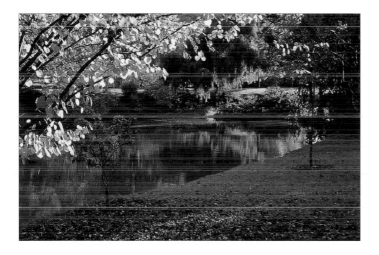

Opposite: The stunning characteristic peeling bark of a spectacular maple, an *Acer griseum*, one of the many rare trees Gilles de Brissac planted while creating the arboretum, enriching the winding walk around the valley lakes.
Left: A view of trees and shrubs reflected in the dark mirror of the lake.

style of gardening, and the charm of English villages bright with flowers. He remembers an extraordinary park filled with exotic water birds and a garden planted with delphiniums, and has never forgotten her generosity and kindness.

When he was fifteen he stayed with friends of his grandparents in Scotland. His host, Lord Clydesmuir, offered him a glass of sherry before dinner and every evening lugubriously played Bach on the organ. His

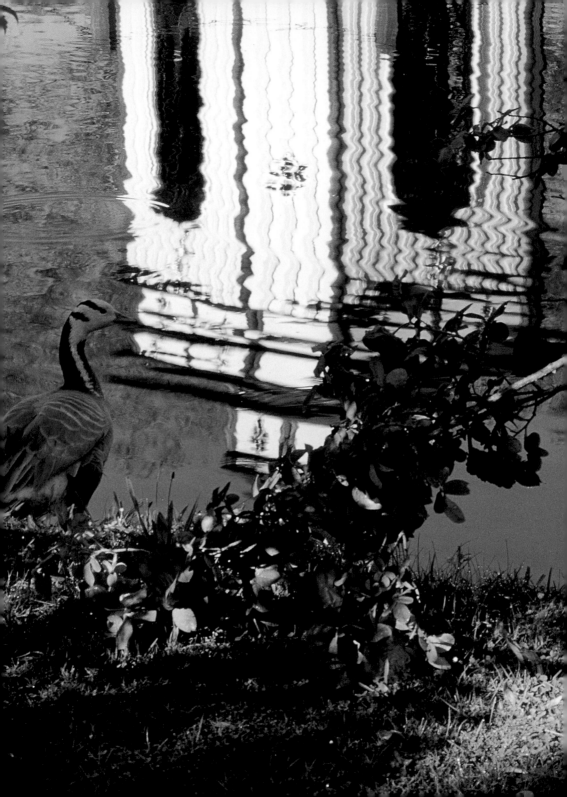

wife was tiny, and was always dressed in pink and lavishly powdered. They were also kind and attentive to their young visitor. He discovered their somewhat abandoned garden and, hardly knowing what he was doing, began to weed it; at dinner he asked his hosts, who had never worked a garden, about seeds and planting. Lady Clydesmuir was touched and interested.

The pattern of long afternoon drives to visit gardens began again, this time riding in the back seat with his lightly veiled hostess while the ancient family

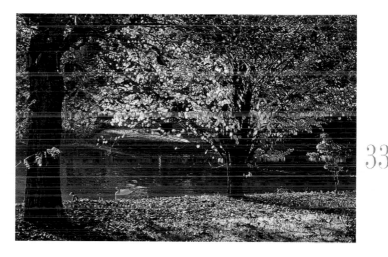

33

chauffeur drove. He visited great formal gardens, took tea with their owners, and questioned the gardeners.

At the end of that summer he returned to France and joined his parents at La-Celle-les-Bordes, the family's seventeenth-century château in the Valley de Chevreuse near Paris. He saw that the grounds were in a disgraceful state and insisted on an English garden and lawn. His mother May, Duchess of Brissac, agreed and encouraged him to design and plant the garden.

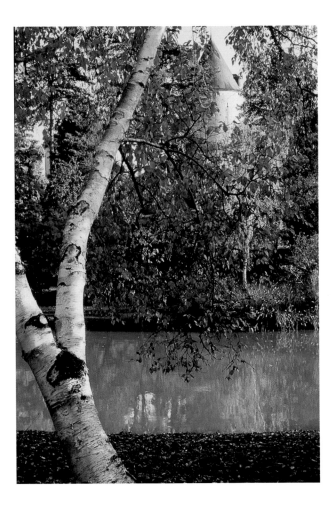

The chapel tower, *above*, seen beyond a paper-white
birch bordering the first lake. A close view, *right*,
of the bark that gives this American tree its common
name.

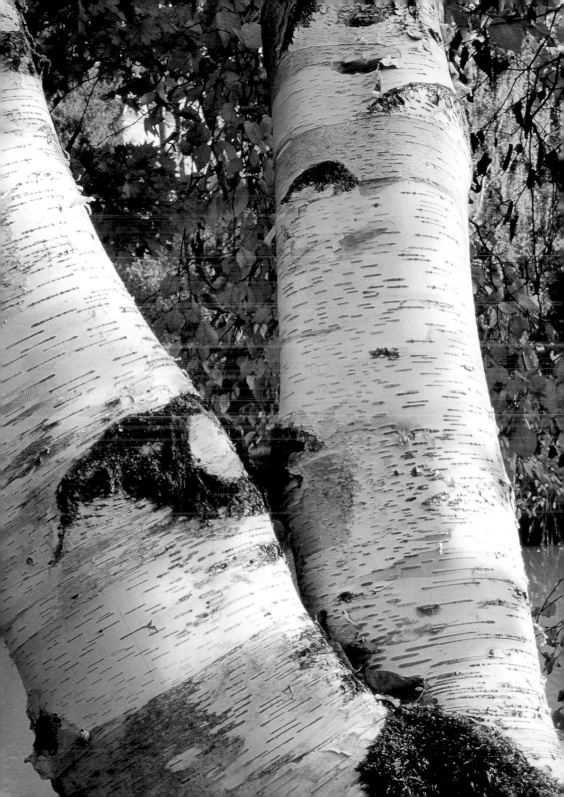

Although imbued with the natural English style, his plans embodied a strong structure to reinforce the mixed borders and other planting, which included a line of small box buttresses to hold the upper slope and a high hedge of clipped hornbeams, inspired by a design at the Trianon at Versailles, its high arches opened toward the view of town and valley. When asked why the garden was so formal, he says, "I am desperately French. I absolutely need the structure of architecture in a garden as I do in a house or room. Very early I was marked by my grandparents' very formal gardens at La Clairière. That was my beginning." Structure remains the controlling element in all his garden design.

Friends of his parents helped the budding garden architect, among them Jacqueline de Chimay and above all the Vicomte Charles de Noailles. This great amateur of gardens, a man of exquisite taste and manners and a grand seigneur of the eighteenth century, virtually adopted Gilles de Brissac as his heir apparent, mapped out English garden tours for him, wrote letters of introduction, gave advice, and delighted in bringing him rare plants. Others who came to the ritual Sunday lunch at La-Celle-les-Bordes admired the garden and asked him to do something with their gardens.

After his military service he became a professional garden designer. Working for private clients brought

both good and bad experiences. Among the best was the making of an enormous mixed border for the Baroness Edouard de Rothschild at Chantilly, the kindest of clients, who then became a friend. But after his grandmother's death, he says, "I asked myself: why exhaust myself when Apremont, a unique experience, exists and a solution must be found. So much talent and money spent, we can't let all this decay and fade away. How could I bring this place into the twentieth century? My grandparents' world had passed, their generation

gone, but their work saved to profit new generations. And all I really knew how to do, and mainly thanks to their encouragement, was to make gardens."

His parents were appalled that he wanted to stop his practice and enraged that he might block the sale of Apremont by creating a public garden. His mother had never liked the place, and had decided to sell off the village houses, the tracts of forest, and eventually the entire property. He settled in the castle nevertheless,

Above: Hostas, *Iris sibirica*, and Japanese azaleas along the lake walk in spring.
Overleaf: The symphony of spring green foliage behind the mixed border of solid plant geometry and delicate flowers in the magnificent White Garden, backed by the topiary hornbeam pointed towers.

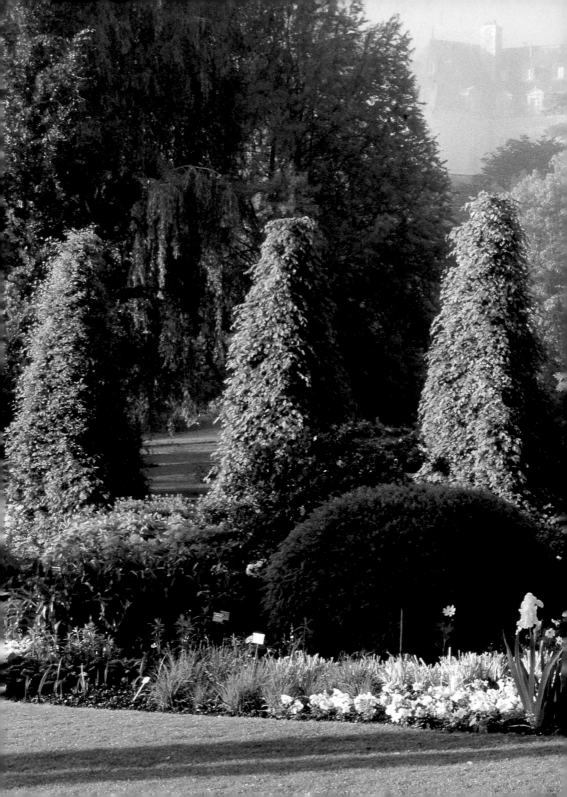

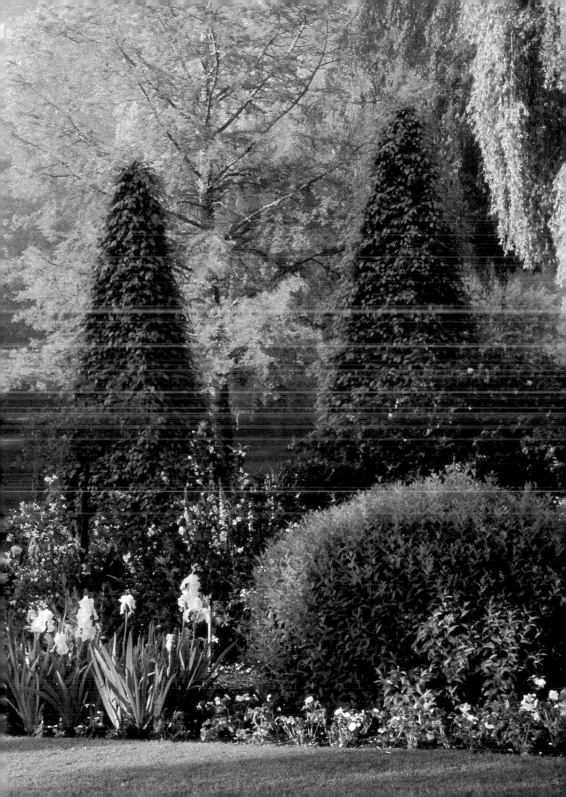

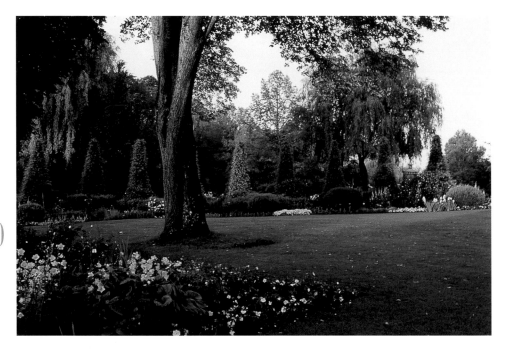

Evening falls on the White Garden, the starting
point of the park and its gardens, with a far glimpse
of the red pagoda roof of the Chinese bridge over
the first lake.

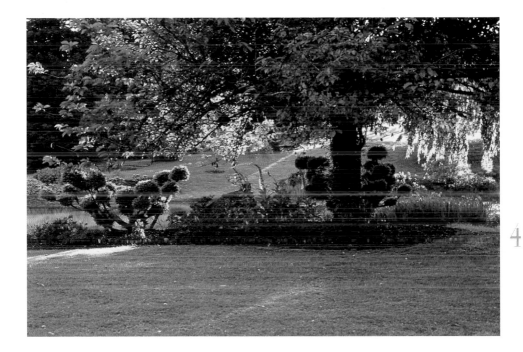

Many of the shrubs, including these junipers,
underplanted with bright flowering azaleas
and shaded by a Japanese cherry, are pruned into
a series of loose balls.

Overleaf: The long white racemes during an early morning watering, which adds a silvery backdrop.

and endured his parents' pressure, including cutting off the heat that winter, to make him leave. One evening, he sat in the drawing room known as *Le Salon des Dames* because it was hung with portraits of his maternal ancestors. Women, above all his beloved grandmother, had given him love and confidence. "After all," he thought, looking at the surrounding pictures, "they too must have had terrible trials in their lives.

Shake yourself and go to work. And I had Gérald Mandon with me, a faithful ally who understood the logic of the project since the first day and was there to share the dare and the risks."

Mandon was a graduate of the prestigious Ecole d'Horticulture at Versailles, in the same class as Alain Provost, his friend and mentor and the chief architect of the Parc André Citroen in Paris and the Thames Barrier Park in London. He and Gilles de Brissac became friends and collaborators early on, and his understanding of landscape, the depth of his knowledge, and his experience in public design became a precious element in the race against time at Apremont. His unstinting help was definitive in the creation of the floral park.

Above: A view of the medieval village, and starting point of the garden, at Apremont. Opposite: Arum lillies surprisingly resist the harshest winters in this cold continental region of central France, but many plants were unable to survive the climate's extremes.

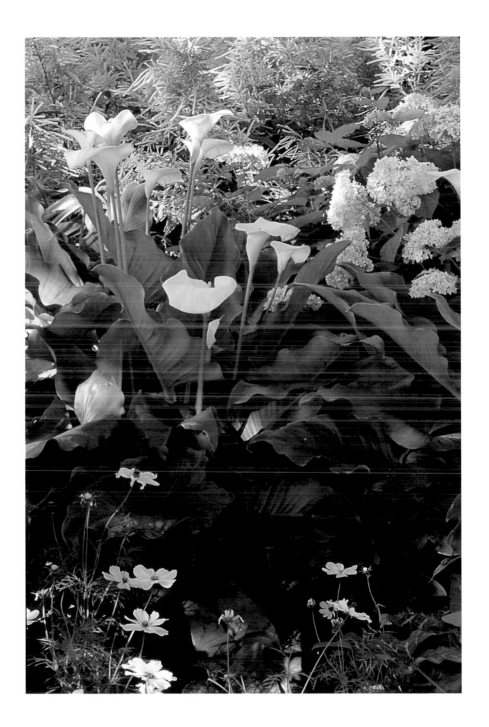

43

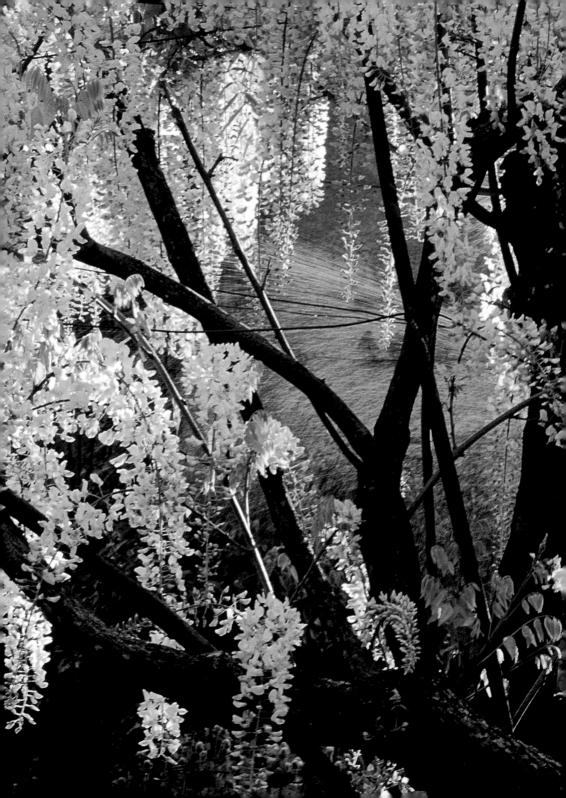

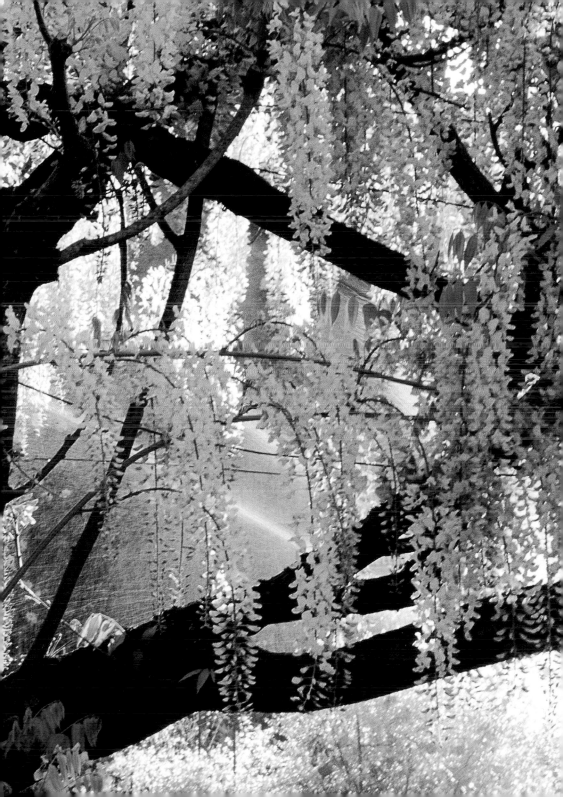

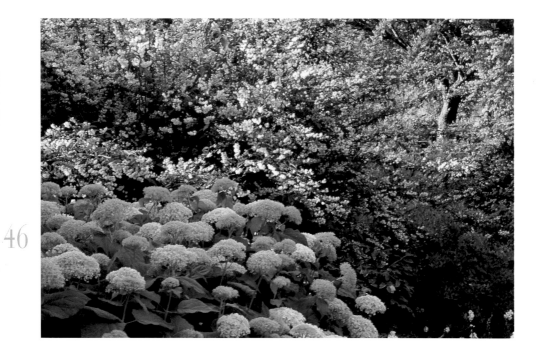

A planting of Hydrangea 'Amabelle' and *Deutia* 'Pride of Rochester' along the path from the White Garden to the park.

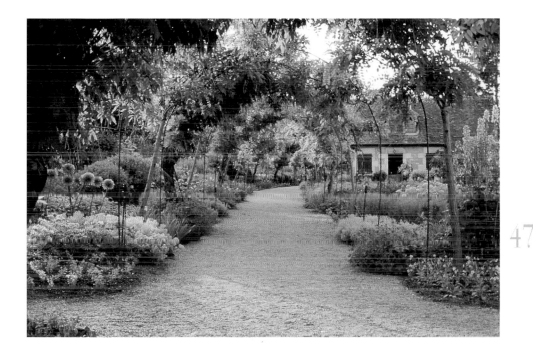

A pergola of rounded Romanesque arches covered
with Japanese wisteria shades the path bordering the
cottage-style gardens that frame the village houses
to the right of the graveled garden path.

The Making of
the Floral Park

Opposite: Huge mauve globes of *Allium gigantium*, an ornamental garlic, mixed with the violet Iris 'Shipshape' along the same path. Every bed and border at Apremont is conceived to teach unexpected combinations of plants and to introduce lesser-known species.
Overleaf: The pergola heavy with blooming white and blue *Wisteria japonica* in full glory. Gilles de Brissac had tried a triple planting in waltz time of golden laburnum, pink acacia, and wisteria, which failed, but the result of the actual planting is simple and marvelous.

The work was not always easy. Apremont shares the climate of continental Europe, like Germany and Switzerland, but Gilles de Brissac had only made gardens around Paris and in the softer climates near the Atlantic. Berry in central France has a harsh, extreme climate; winters are bitterly cold and summers torrid. There were some disasters, too. One nursery sent him dead elms, another sold him magnolias that didn't survive a winter. Many plants languished, others died off. Spring blooming ceanothus were too delicate, rhododendrons became haggard in the heat, and the gardeners were bad. There were also good surprises. Charles de Noailles had brought crimiums to La-Celle-les-Bordes, whey they had malingered; Gilles de Brissac, an inveterate transplanter, moved them to Apremont, where they thrived and multiplied, as did all the bulbs native to South Africa and the alstromerias of Peru. Large flowered clematis grew gloriously.

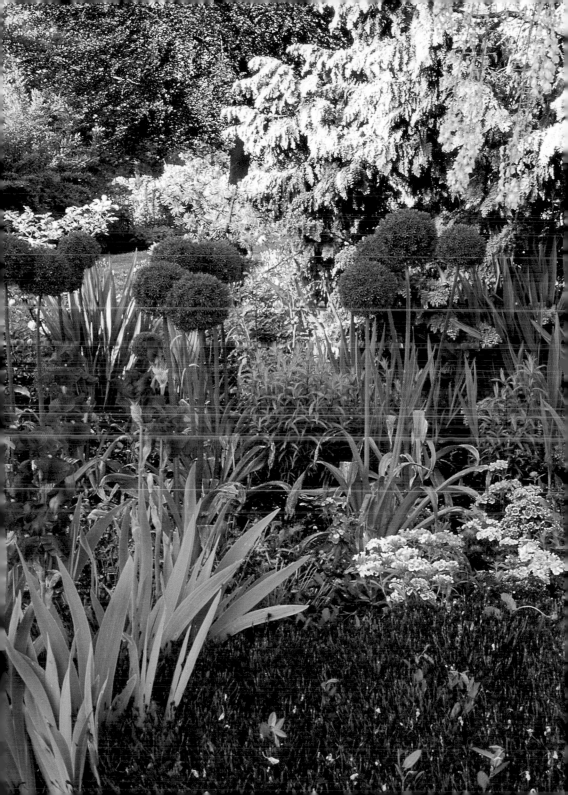

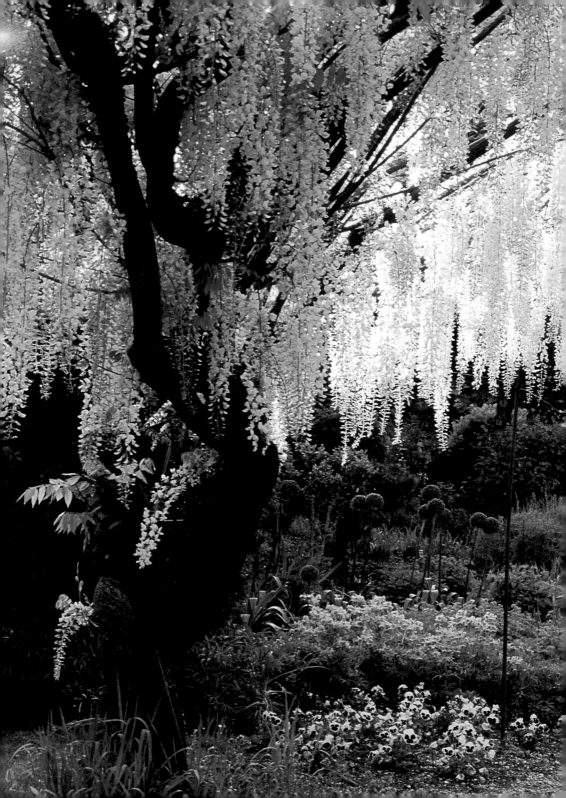

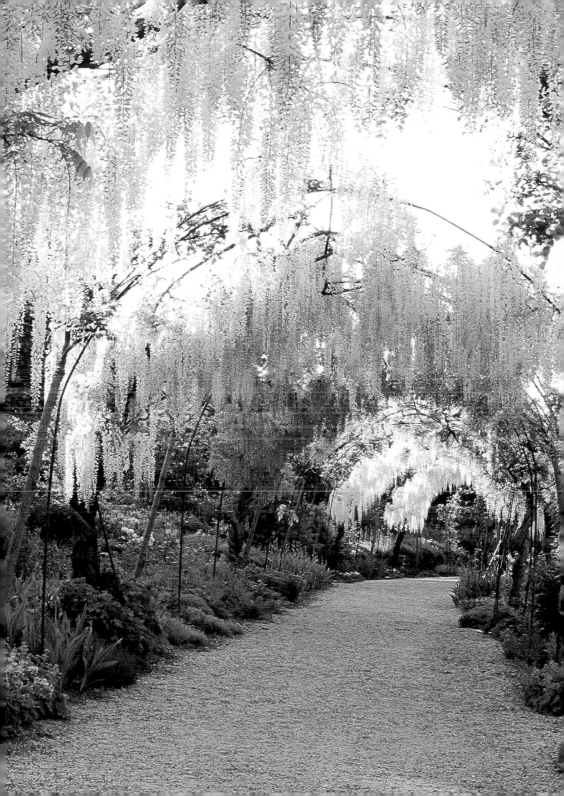

Below: An old well that served the village for many generations at the edge of the traditional marketplace, now the lawn between the White Garden and the pergola.

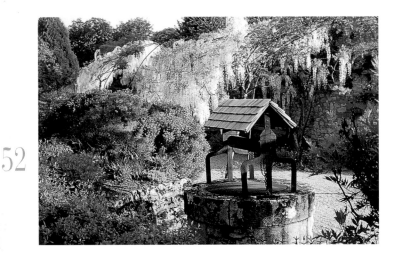

Opposite: Clematis jacmanni before a background of full-blown double tulips. There is a fine collection of clematis that thrive in the soil and climate of Apremont.

"I wanted to do better than everyone. I wanted to conjugate everything at the same time and I failed," he admits. "It took time to understand Gertrude Jekyll's comment that it takes half a life to dicover what to plant and the other half to learn how to plant it. For example, I wanted a pergola. First the structure was wrong, too flat when I wanted it rounded like a Romanesque abbey. The cascade of golden laburnum in flower at Bodnant enchanted me, as did the Duchess of Mouchy's pergola of pink acacias, and why not add the Japanese touch of hanging wisteria, a pergola like a *valse à trois temps*. It would have been perfection, but it didn't work the way I hoped. Neither did the spring nor the summer border. That was my systematic French side, a longing for classification *à la Buffon*. Then nature takes over and mixes everything. Every element in a garden is a piece of the puzzle. A garden refuses many pieces. The plants themselves refuse to grow, refuse because they are ill-placed. One's own intuition has to come in play."

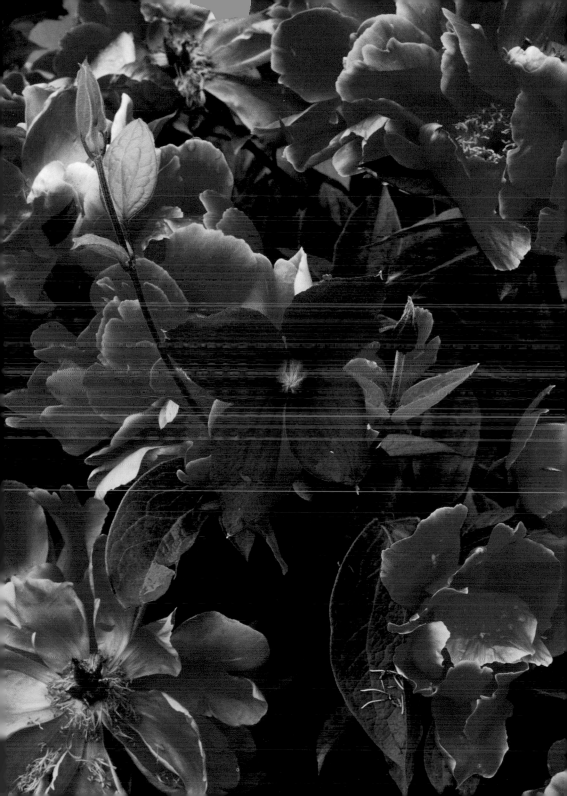

Previous pages: One of the cottage gardens stretching beside the pergola and the graveled path, once the back road through the village.

Opposite: A sharp note of red in one of the mixed borders.

The first step was to landscape the village, already a place of enchantment, and integrate it as the introduction to the floral park; to make open, generous gardens a world away from the enclosed, guarded French gardens—gardens to be seen and enjoyed by all like those he had seen in English villages.

The white garden, an homage to Sissinghurst, would be the starting point of the floral park, circling what had been the old village square with its four huge lime trees and a group of small houses—a theatrical stroke of genius. As he explains, "Thankfully, my grandfather bought the unpaved road that traversed the back of the village from the commune just before the war. Thank God it was mine to destroy, otherwise the garden circuit would have been impossible."

One stumbling block that later became a major asset was the stone quarry, a terrible eyesore long-abandoned and used only as a dangerous slide by the villagers and a hideous obstacle to the natural continuation of the floral park. But it held a beautiful view and had the castle as a dramatic backdrop. Ironically, it had to be restocked with stone before becoming part of the overall design. Certain family stocks came to maturity just when the money was needed, and the proceeds from their sale bought six hundred tons of stone as well as hydraulic pumps to create the cascade and the scenic

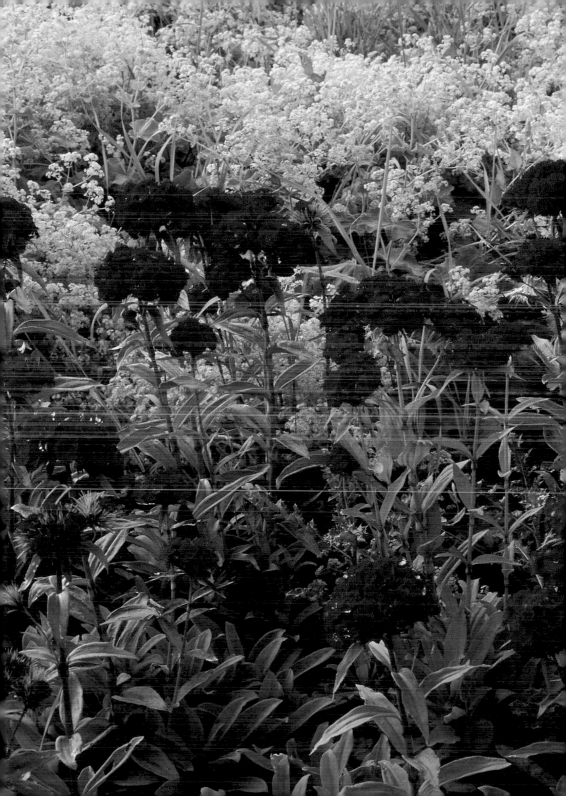

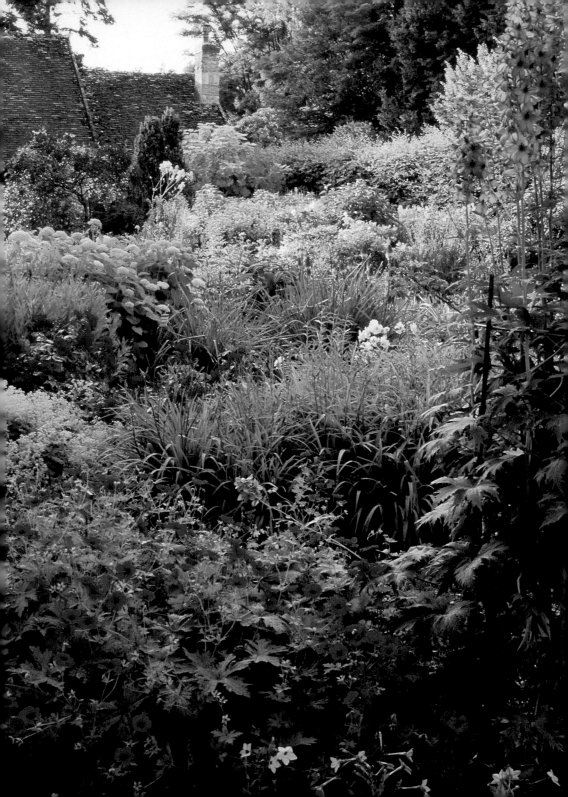

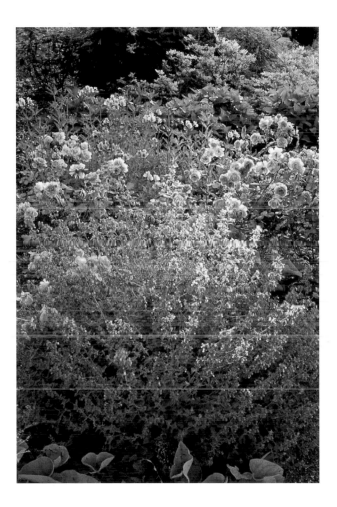

Opposite: The exuberance of shape and color
of the massed perrenials and bi-annual plants in June.
Blue nepeta, our cat-mint, and the generous Rosa
'Milroses,' *above*.

The many water fowl, from the black swans to the ducks, contribute to the colorful life of Apremont.

descent. In 1998 Gilles de Brissac placed a striking contemporary sculpture in painted wood, *Genie of the Waters*, by Portuguese sculptor Baptista Antunes, in the center of the cascade.

The next step was to seal off the valley to use the minuscule stream, barely a foot wide, to create a series of joined lakes and ponds inspired by Sheffield Park in England, doubling the space of the park. "Little by little the meadows where once drowsed the placid white Charolais bullocks were transformed into lawns, mixed

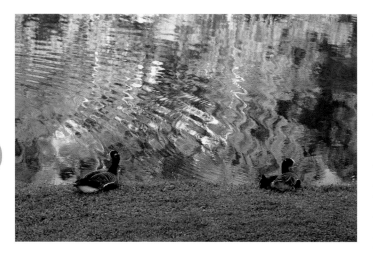

borders, and planted with groups of shrubs and trees."

Great numbers of trees were chosen for the arboretum. They were enormous, each weighing at least three tons. When they were delivered panic set in: "Trees are something else again." The men, paid by the hour, were waiting for instructions. He was alone before the empty landscape to be planted. Three large sequoias were placed. They made a solid axis. A very large willow was carried to the peninsula. He began to relax.

The landscape began to look organized. The hours were long, the November weather horrible, but the result seen now is of timeless beauty.

The plan of the garden was now in place, as was most of the planting, but much of the latter was in poor condition due to incompetent gardeners. Then, in 1976, Camille Muller came to visit Apremont. He had trained with Gilles Clément, known for his concept of the "garden in movement" and learned how to care for plants with the Princess Sturdza at Le Vasterival. He timidly said that he

61

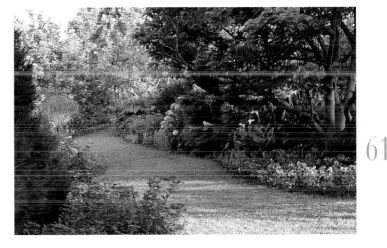

A curving grassed path in the English style runs between massed borders and leads up the slope of a hill to a beautiful viewpoint of lakes, meadows, and the castle at the top of the cascade.

would like to work with Gilles de Brissac. "I was alone. He brought a new eye and a feeling for natural planting, an understanding of the wild garden. He introduced ferns and bamboos and a certain controlled disorder where it was needed. Our differences were complementary and good for the garden." The collaboration and friendship were precious for both. After three years Camille returned to Paris with the precious knowledge that every garden must have an architectural structure.

Overleaf: This inventive mixture of Alstromerias, the Peruvian lily, *Hydragea quereifolia*, and *Arancus dioicus*, known in France as goat's beard, is a fine example of the designer's eye and horticultural talents.

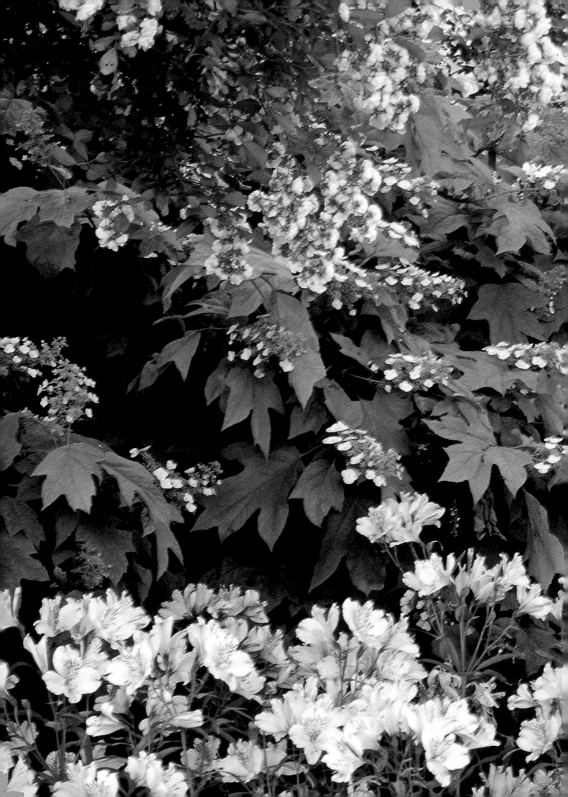

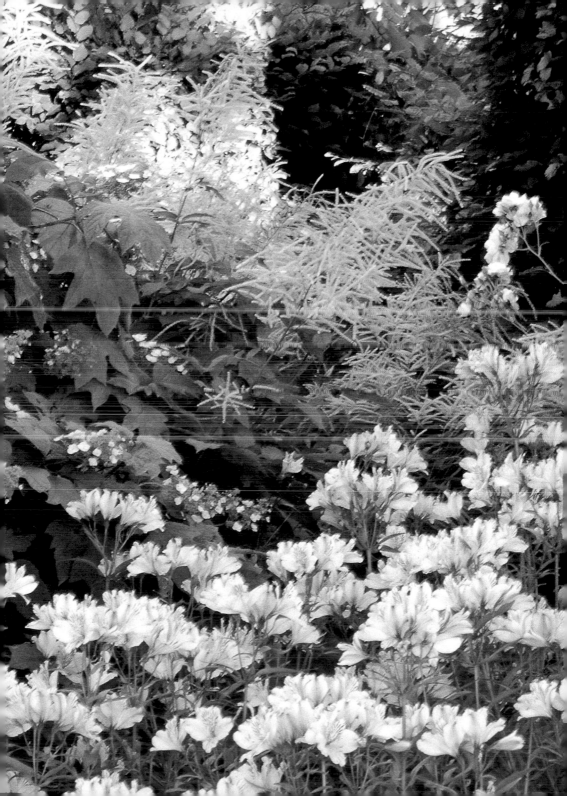

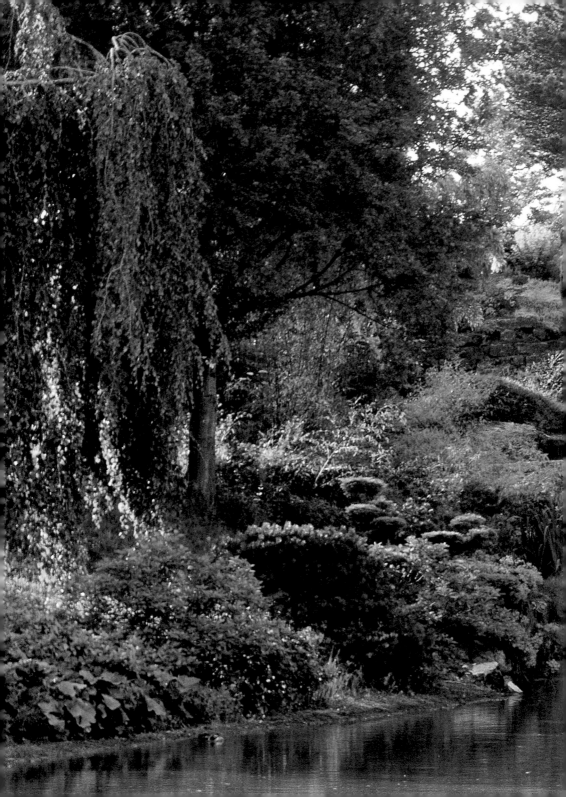

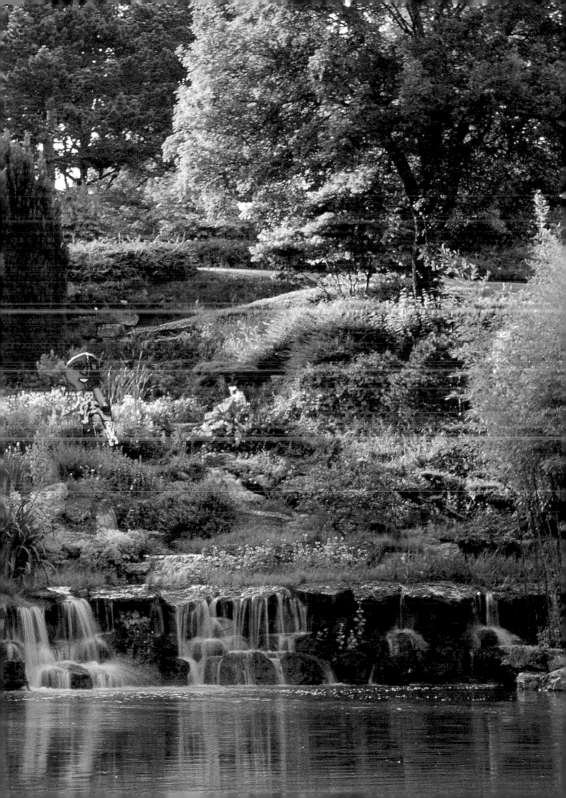

Another essential bit of good luck was the
collaboration with Russian painter and architect
Alexander Serebriakoff and his sister Catherine--a long
and fruitful association brought about by Lilliane de
Rothschild. "They were my spiritual parents, a source
of ideas, imagination. It was like riding on a cloud that
became reality." Together they
worked on the redecoration of the
castle, followed by the design of a
series of architectural follies to add
an element of the exotic to
Apremont. First, in 1985, the
Chinese pagoda bridge was built,
followed in 1994 by the Turkish
pavilion, its enchanting painted
interior an evocation of the shores of
the Bosphorus and past splendors of
the Ottoman Empire. The four

paintings by Jacques Roubinet, who lives at Apremont,
symbolize the four seasons as well as the ages of man.
Their last work, completed in 1997 after the death of
Alexander Serebriakoff, is the Belvedere that overlooks
the park, the village rooftops, and the river. It was
inspired by a visit to the palace of Pavlovsk in Russia.
The interior is decorated with Never ceramic panels
based on a series of watercolors done by Alexander of

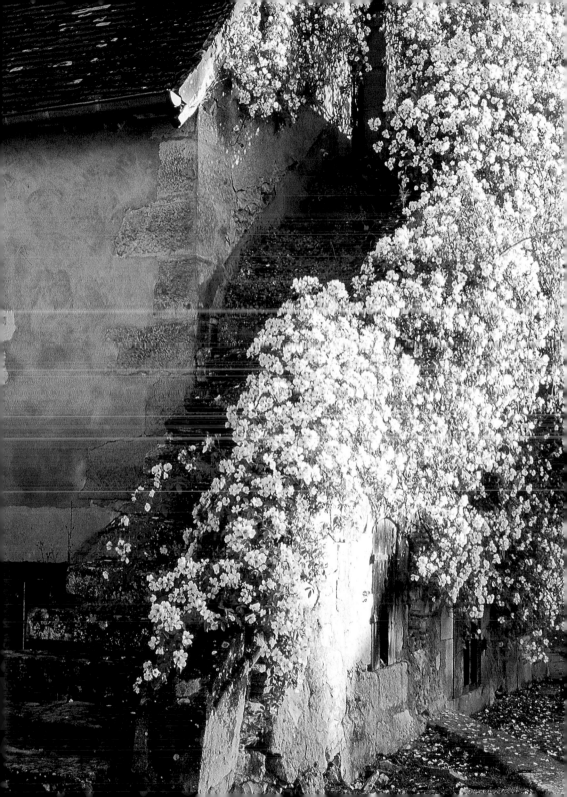

an imagined trip around the world of a band of punchinelli, traditional characters of Italian comedy. Of course, their final destination is a visit to the gardens of Apremont.

Gilles de Brissac remembers his childhood before the war at his grandparents' garden, La Clairière, as his lost paradise. Those early years are the stuff of dreams. They are the origin of his love of gardens and over twenty years of work at Apremont. To create one must have a reason. He quotes Marcel Proust: "We only find our lost paradise in ourselves."

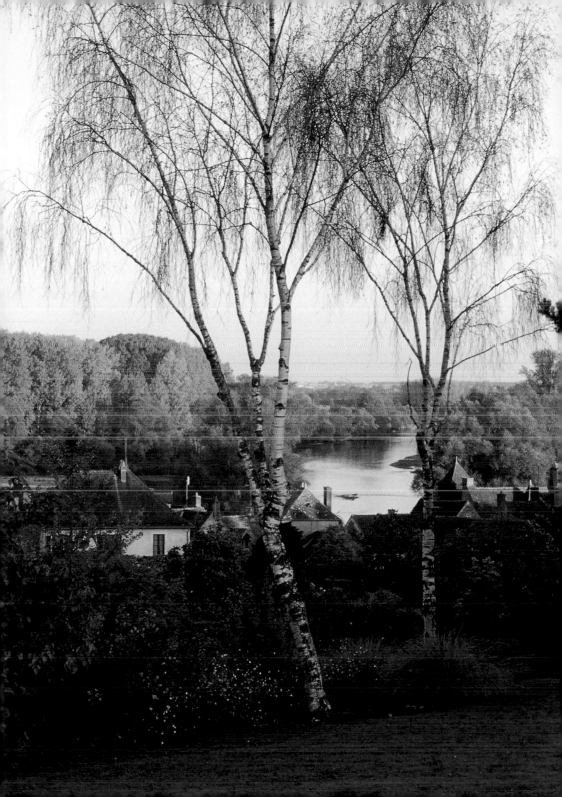

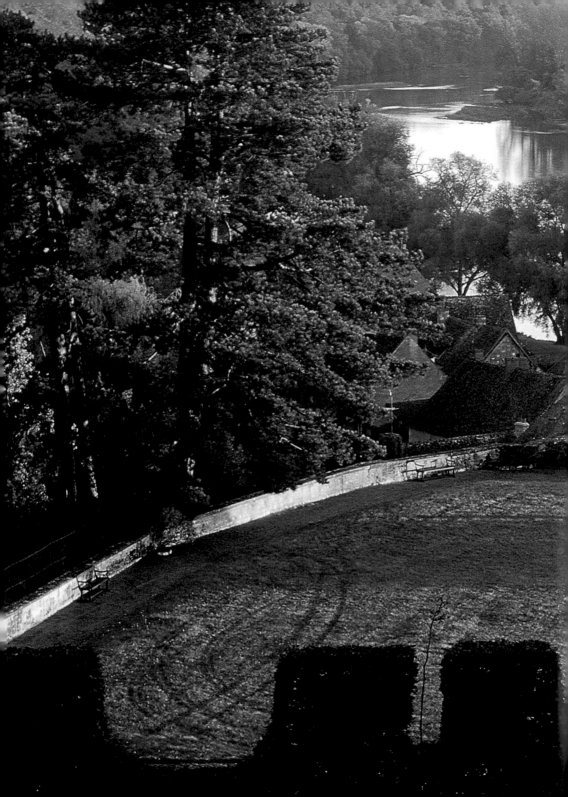

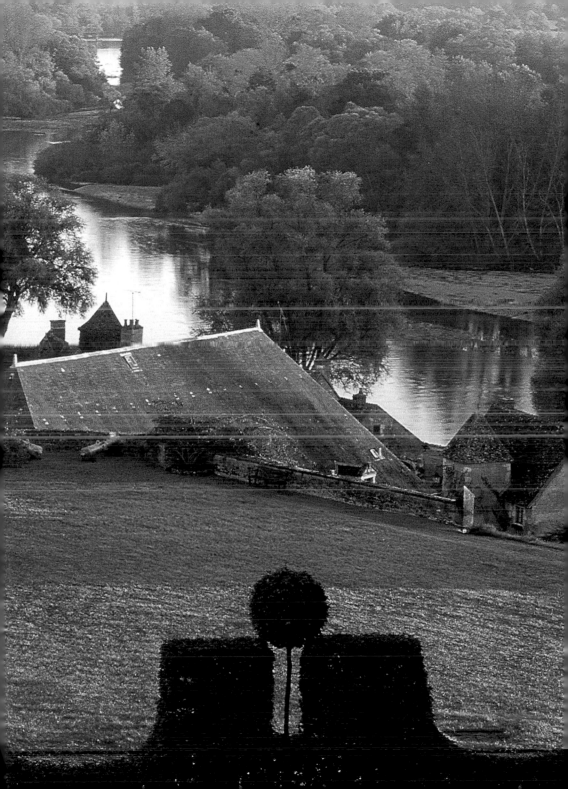

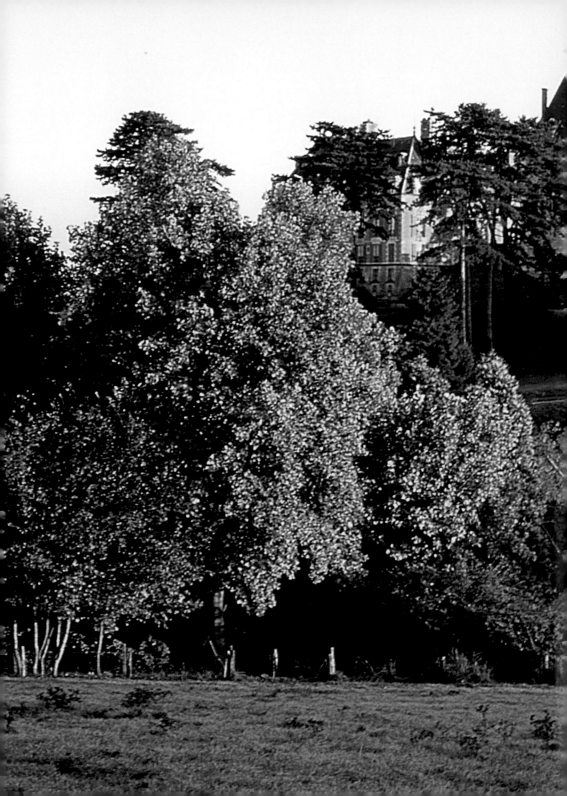

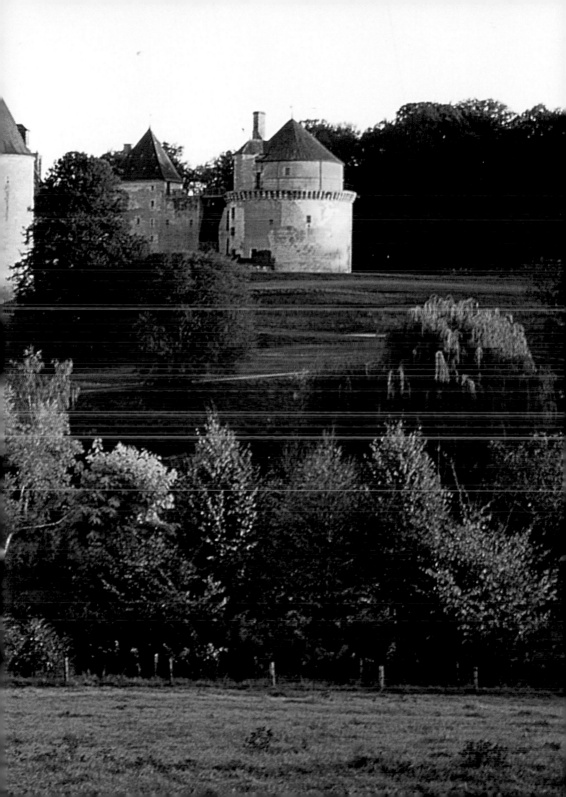

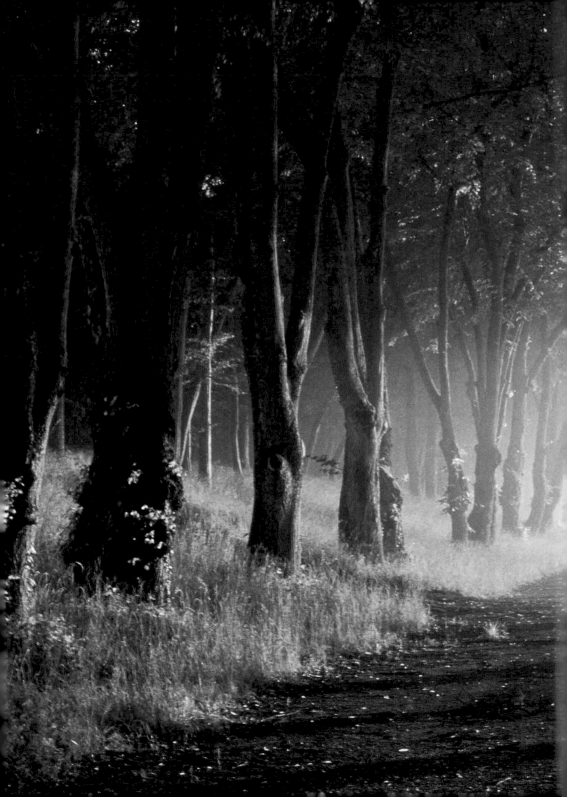

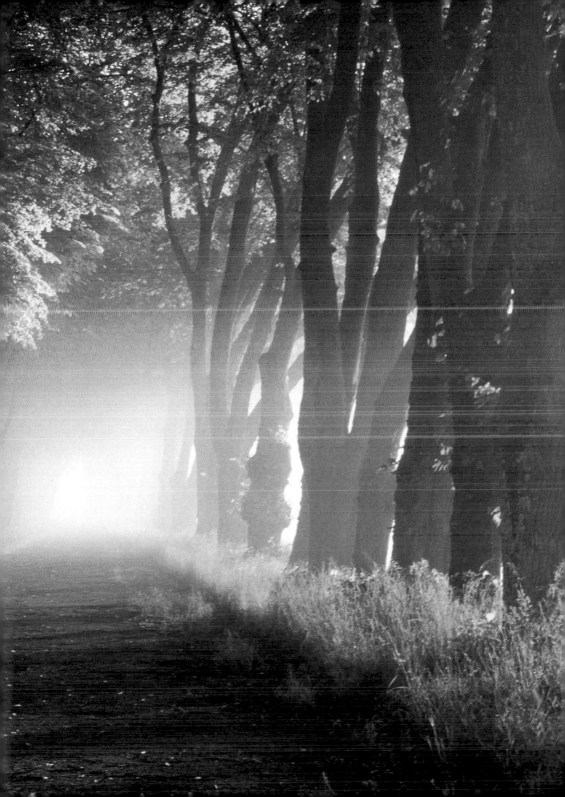

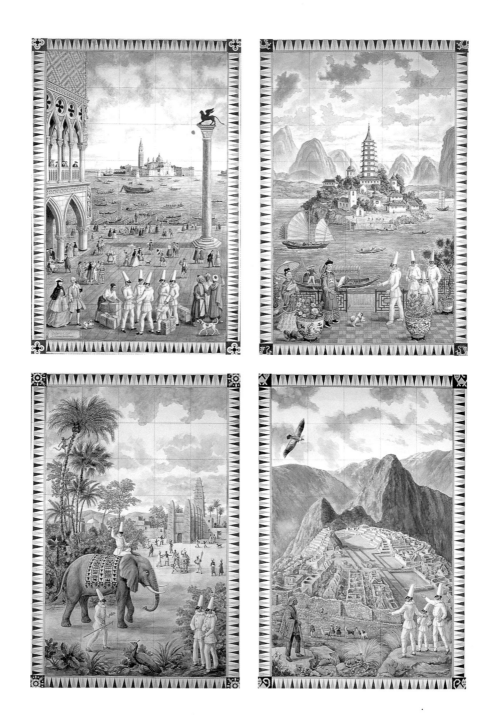

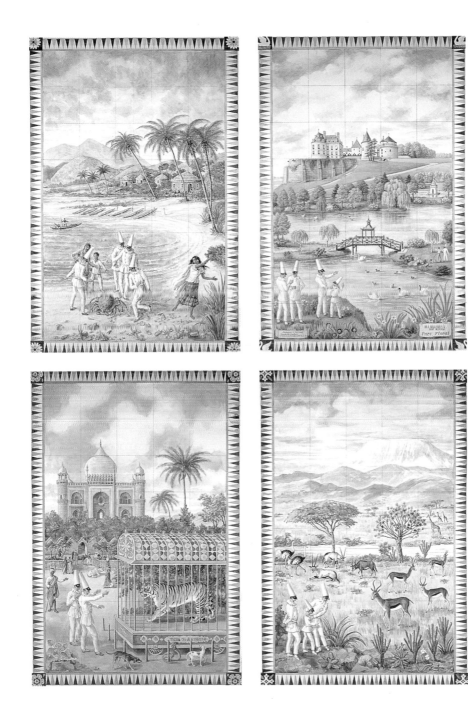

Garden Plan
and Visiting
Information

The Floral Park at Apremont is
open every day from Palm Sunday
to the middle of October.

Visiting hours are from 10 a.m.
to noon, and from 2:00 p.m.
to 7:00 p.m.

Apremont-sur-Alliers lies ten miles
(sixteen kilometers) from Nevers,
twenty-fives miles (forty
kilometers) from Moulins, thirty-
eight miles (sixty kilometers) from
Bourges, and one hundred sixty
miles (two hundred fifty
kilometers) from Paris.

For directions and futher
information telephone (France)
33 2 48 80 41 41, or fax (France)
33 2 48 80 45 17

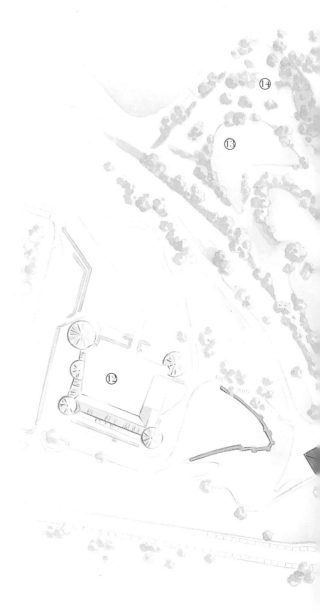

79

to La Guerche sur l'Aubois

⑦

⑨

⑩ ⑧

⑥

⑤

④

② ③

① ⑮

Entrance

to Bourges and Nevers

Allier River

Page 1: A weeping birch
reflected in one of the two
lakes created by Gilles de
Brissac in the valley below the
château of Apremont . . . the
heart of the floral park.
Pages 2-3: The White Garden's
fantastical unique hedge of
clipped pointed hornbeams
framed by a curtain of weeping
willows behind the first lake, a
dream vision that marks both
the beginning and the end of
the park.
Pages 4-5: The Chinese bridge,
the first folly imagined by
Gilles de Brissac and conceived
by the Serebriakoffs, emerges
as an exotic vision through the
early morning mist. The
Chinese red, softened by the
light, contrasts and accents the
variations of green in the
surrounding foliage, and the
vibrant yellow is echoed by the
Iris sibirica in bloom on the
edge of the first lake.
Page 6: A towered house of
the medieval village, once the
communal meeting place, faces
the White Garden and stands
sentry to the first steps of the
walking tour of Apremont's
gardens and landscapes.
Page 8: It is highly unlikely that
Antoinette de Saint Sauveur,
the wife of the powerful
master of the Forges of
Creusot, ever rode on
horseback over her domain of
Apremont in costume, as
depicted here by Madame
Mantovani-Goutty in 1903.

Series editor Gabrielle Van Zuylen

Designed by Marc Walter / Bela Vista

Copyright © 1999 The Vendome Press
Photographs copyright © 1999 Claire de Virieu
Text copyright © 1999 Gilles de Brissac
and Gabrielle van Zuylen

Published in the U.S. in 1999 by
The Vendome Press
1370 Avenue of the Americas
New York, N.Y. 10019

Distributed in the U.S. and Canada by
Rizzoli International Publications through
St. Martin's Press
175 Fifth Avenue
New York, N.Y. 10010

Library of Congress Cataloging-in-Publication Data
Van Zuylen, Gabrielle.
Apremont / by Gabrielle van Zuylen and Gilles de Brissac ;
photographs by Claire de Virieu.
p. cm. -- (Small books of great gardens)
ISBN 0-86565-204-X
1. Parc floral d'Apremont (La Guerche-sur-l'Aubois, France)
I. Brissac, Gilles de. II. Title. III. Series.
SB466.F83 P379 1999
712'.0944'552--dc21 99-30843

Printed and bound in Italy